Trivial Pursuits

ORLANDO GILI

Trivial Pursuits

THE ENGLISH AT PLAY

HOXTON MINI PRESS

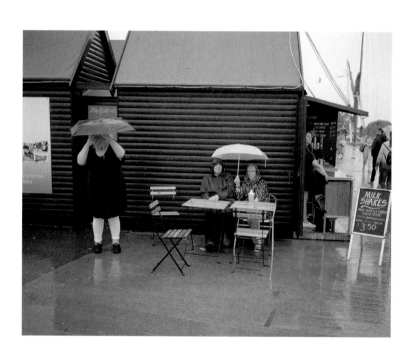

Introduction

Hoisting a 60lb woolsack onto your shoulders and then running up a steep slope is a featherbrained undertaking. Doing it after drinking beer, idiotic. Even so, inspired by the spinners and sheep drovers who once thronged the Cotswold Hills, villagers in present-day Tetbury do it every year, on the Whitsun bank holiday.

What is it with Gloucestershire? Because 20 miles away in Brockworth, scores of people think nothing of hurling themselves down a grass hill after a huge wheel of cheese. The winner is the first to catch it, and bones have been broken in the pursuit. Locals insist that the pastime began in pagan times and was eagerly adopted by the Ancient Romans, when they invaded Britain in 55BC.

Such majestically bizarre activities don't stop at the Watford Gap, either: the North of England is equally implicated. In Hallaton, Leicestershire, for instance, it's considered fun for two teams to gorge on hare pie before competing to move a small yet incredibly heavy, ball-sized wooden barrel filled with beer across one of two streams a mile apart.

A little like modern-day rugby, then, and another pastime rumoured to have been popular with Julius Caesar's Roman legions (I'm beginning to wonder how they found time to build all those aqueducts and, well, conquer most of Europe and North Africa).

Whether these public rituals and entertainments really began centuries ago (or were dreamt up after a few pints in the pub in the Seventies) is besides the point. The activities that we English go in

for in the name of play, pleasure and the pursuit of happiness, help create a narrative concerning our place in the world.

Every known society has evolved such rites and rituals: perhaps communities cannot survive without them. They place us in the continuum, rooting us to what has gone before. They're also a diversion: happy-making and veined with the 'gentle madness' – to borrow the words of the late Tony Ray Jones – that overtakes the English when they decide to cut loose.

In *Trivial Pursuits,* Orlando Gili has sought to discover the quintessence of Englishness, laying bare some of the ways in which we can be distinguished from all other people in the world.

He began in 2018, intending to cover the lead up to the official Brexit breakaway, though the impulse was anthropological rather than politically charged. Along with some of the events that form the traditional English 'Summer Season' – Glyndebourne and Wimbledon and so on – are war re-enactments, gatherings of fans of the TV show *Peaky Blinders,* a festival to celebrate all things Dickens, and royal wedding street parties.

What's not to like? Here is a terrifically awkward group of gangly undergraduates enduring the trials of Freshers' Week. There, a stout-spirited group at Whitstable Oyster Festival battles the ever-unreliable weather (see image on previous spread). Old codgers at Henley Royal Regatta and the Hampton Court Flower Show; teens at the Notting Hill Carnival and at Bestival.

There is a lot of strange headgear, and a lot of dressing up. Overall, it is the similarities rather than the divisions that dominate.

That's because Gili's images focus on the group rather than the individual, offering a panoptic version of English identity; one that emphasises the timelessness and spirit-lifting properties of these pastimes. In doing so, he has sidestepped mockery, considering not the absurdity of this or that individual, but the peculiar way we all behave when given the chance to let our hair down.

Lucy Davies
London, 2020

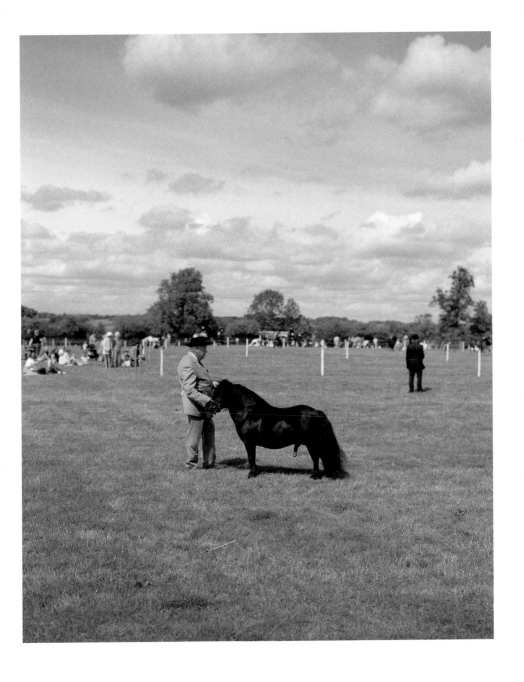

Bucks County Show, Buckinghamshire

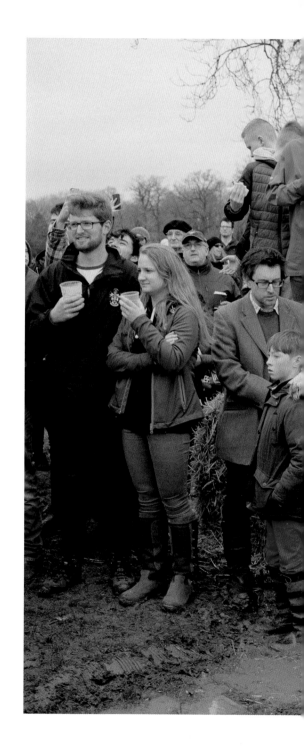

Hallaton Bottle Kicking, Leicestershire

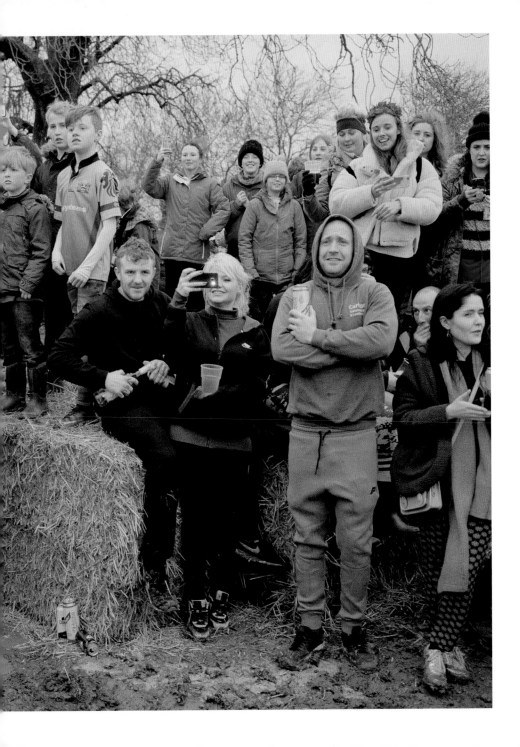

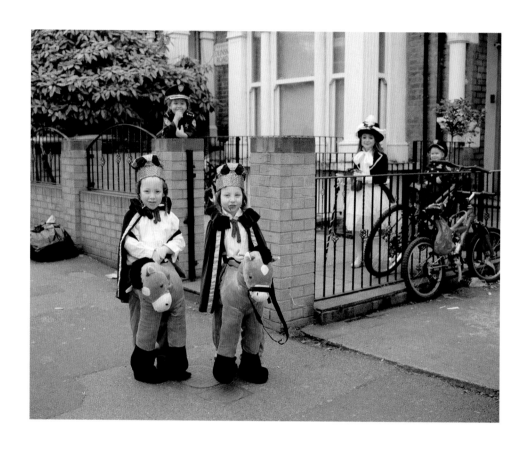

Purim, Stamford Hill, London

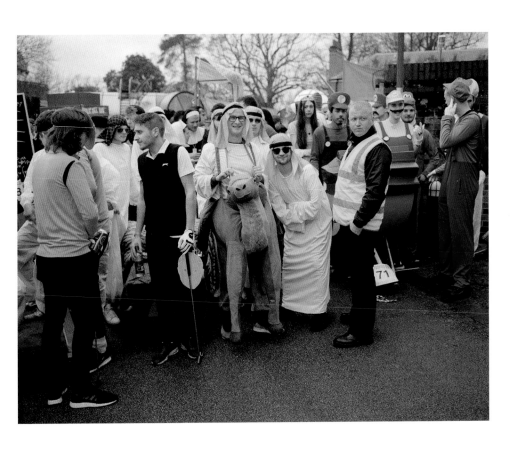

Windlesham Pram Race, Surrey

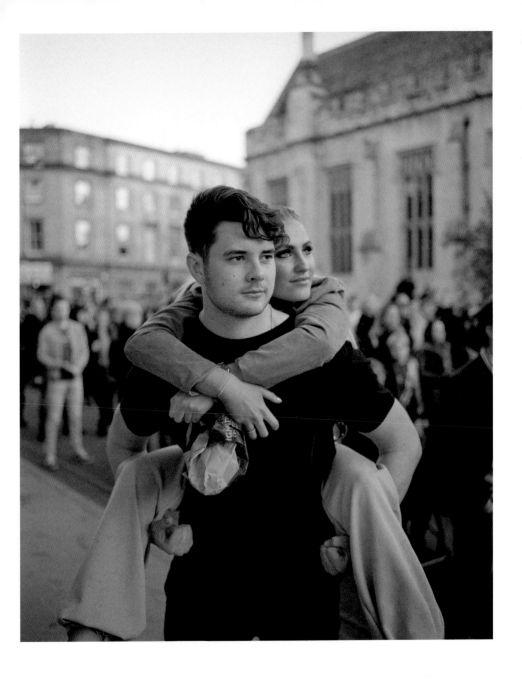

May Morning, Oxford

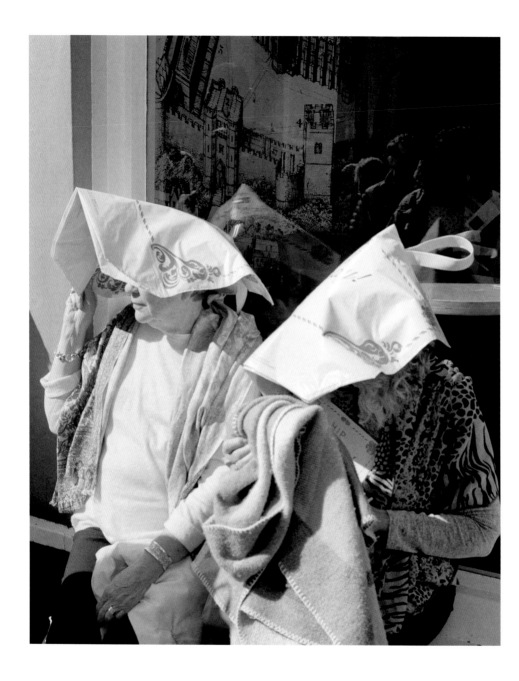

Royal Wedding Day, Windsor

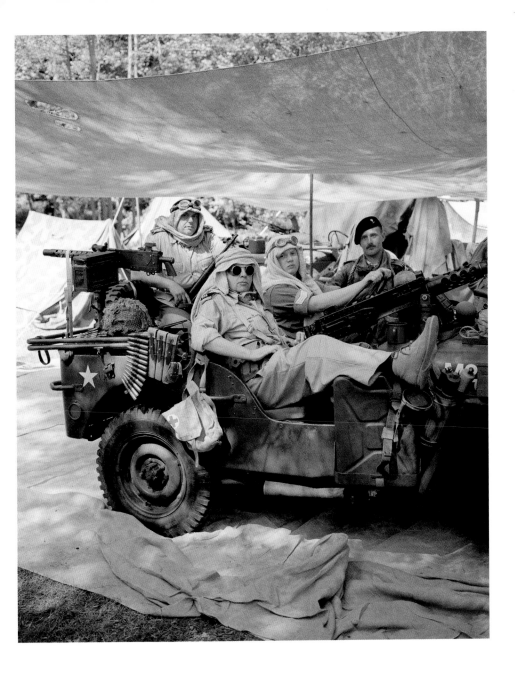

Royal Gunpowder Mills VE Weekend, Essex

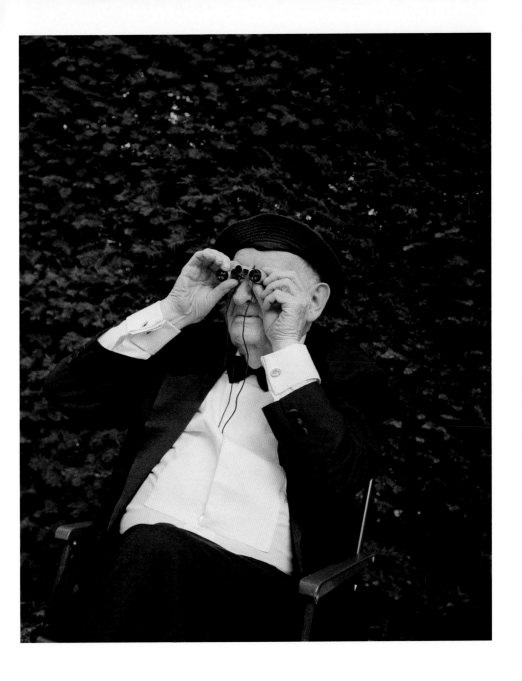

Glyndebourne Festival Opera, Sussex

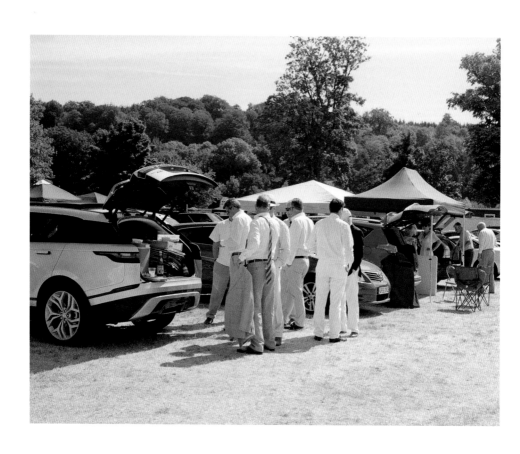

Henley Royal Regatta, Oxfordshire

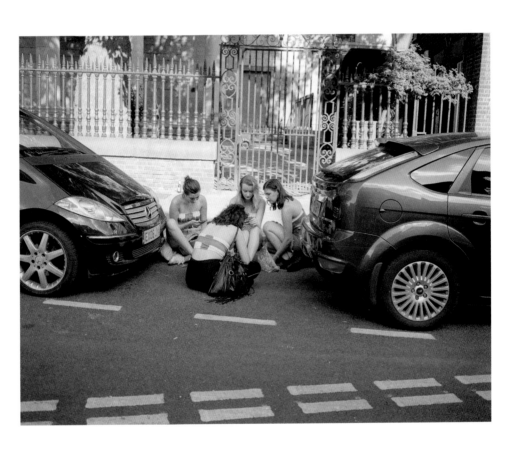

World Cup 2018 England vs Sweden, Shoreditch, London

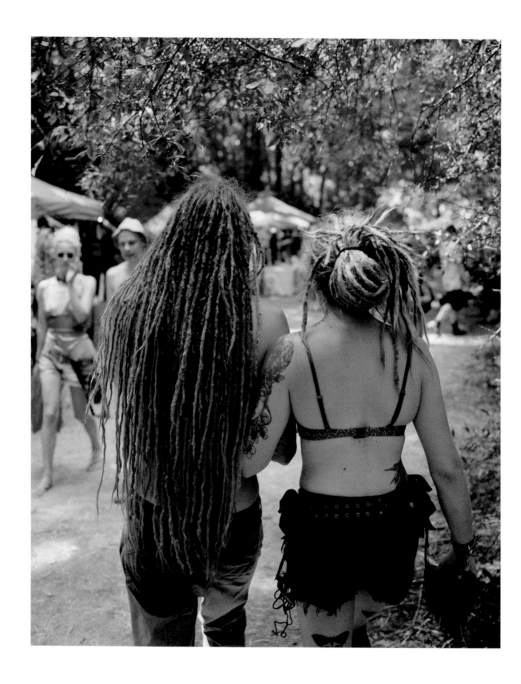

Noisily Festival, Leicestershire

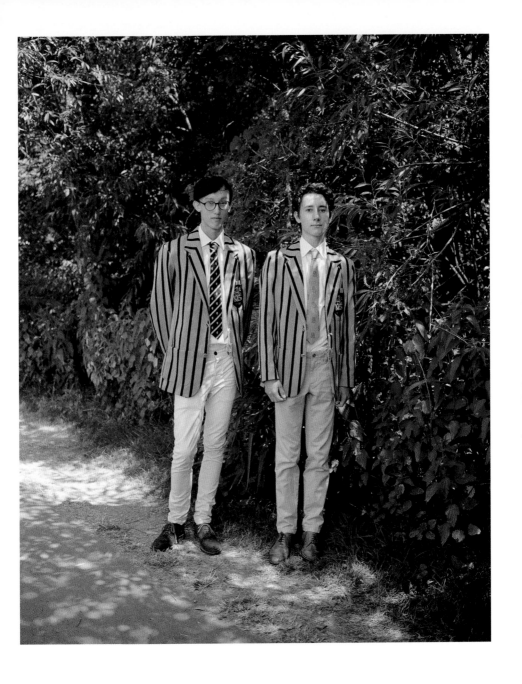

Henley Royal Regatta, Oxfordshire

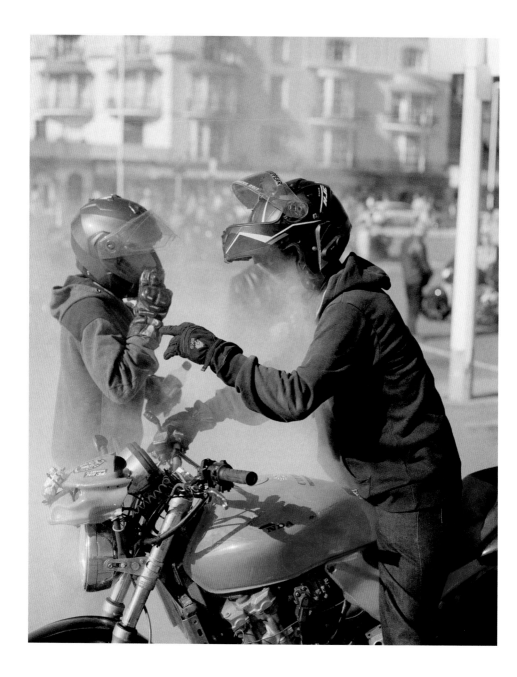

Mayday Run, Hastings

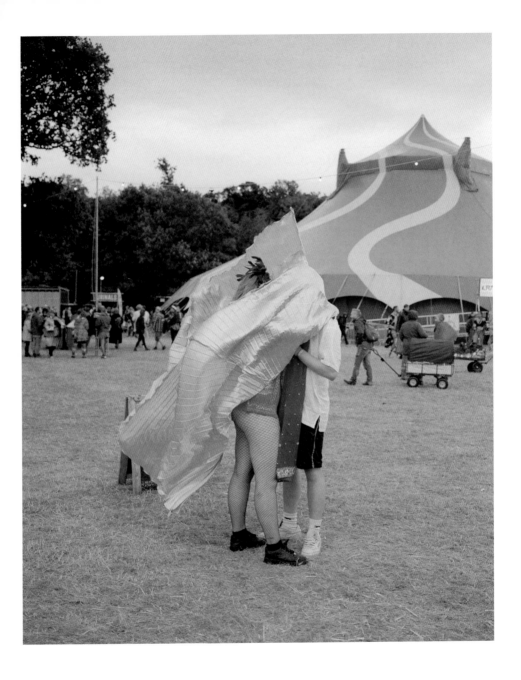

Shambala Festival, Northamptonshire

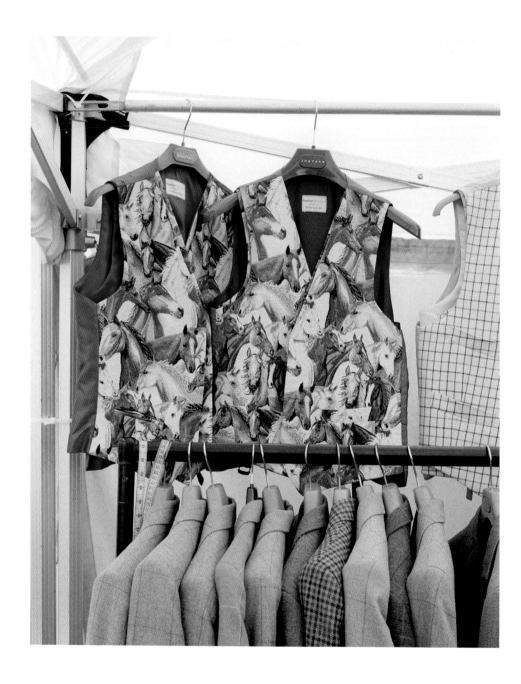

Bucks County Show, Buckinghamshire

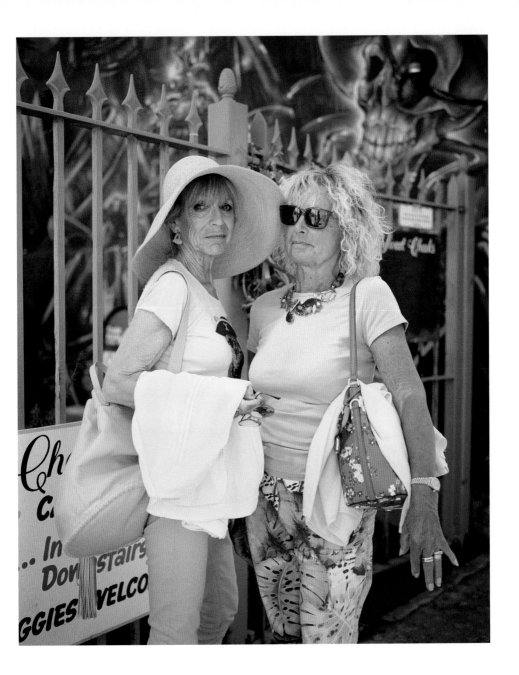

Jack in the Green, Hastings

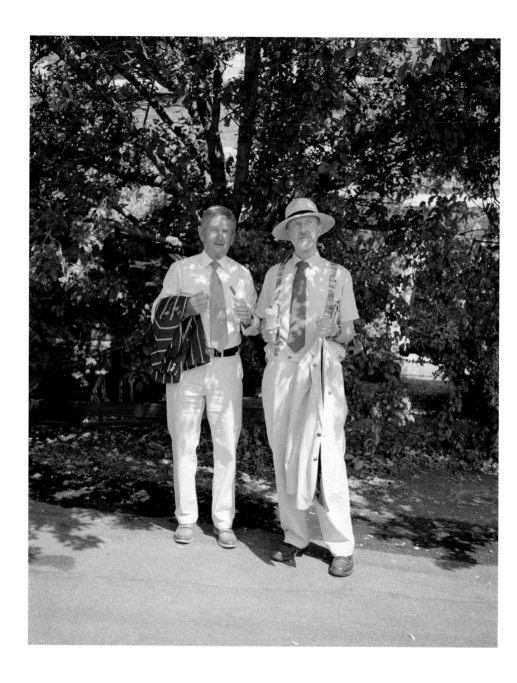

Henley Royal Regatta, Oxfordshire

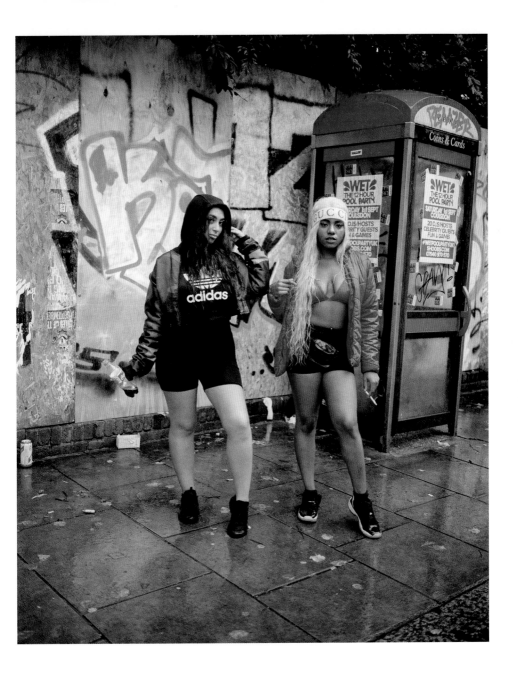

Notting Hill Carnival, London

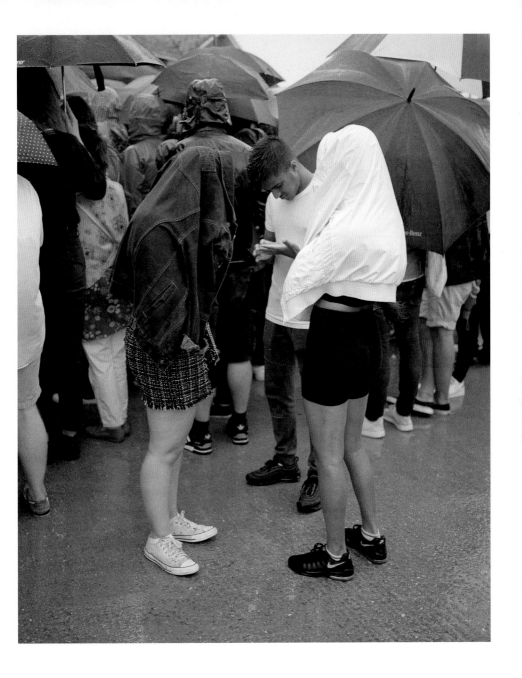

Whitstable Oyster Festival, Kent

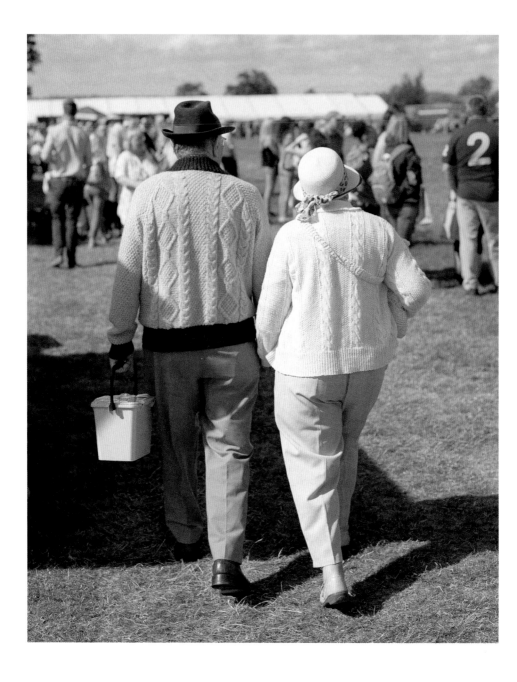

Bucks County Show, Buckinghamshire

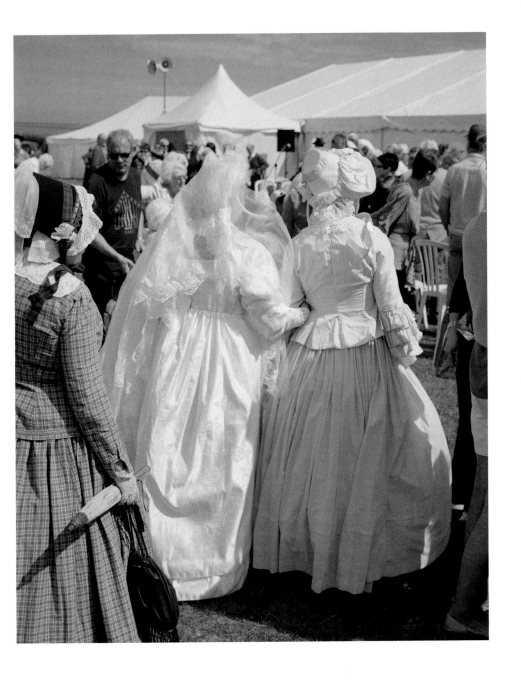

Broadstairs Dickens Festival, Kent

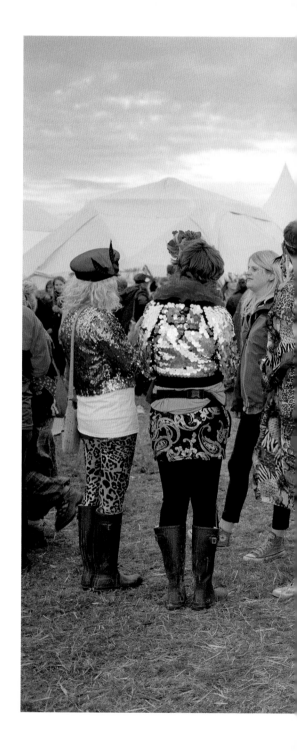

Shambala Festival, Northamptonshire

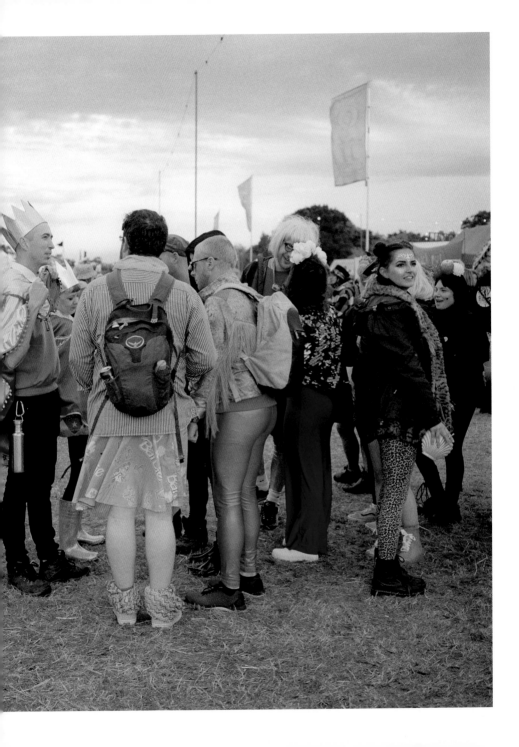

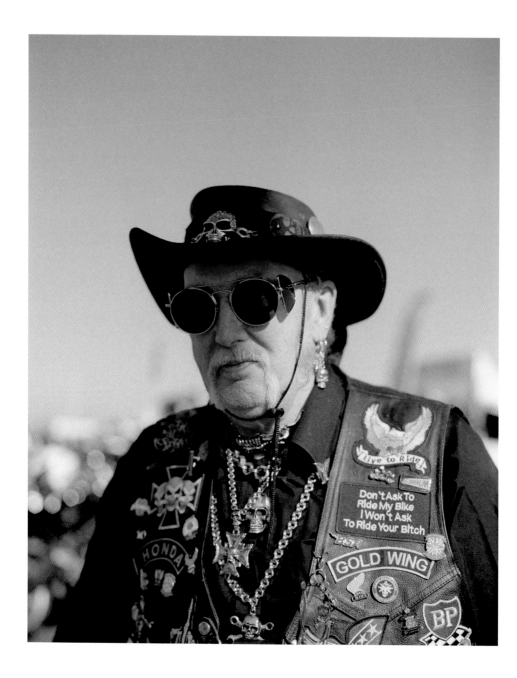

Mayday Run, Hastings

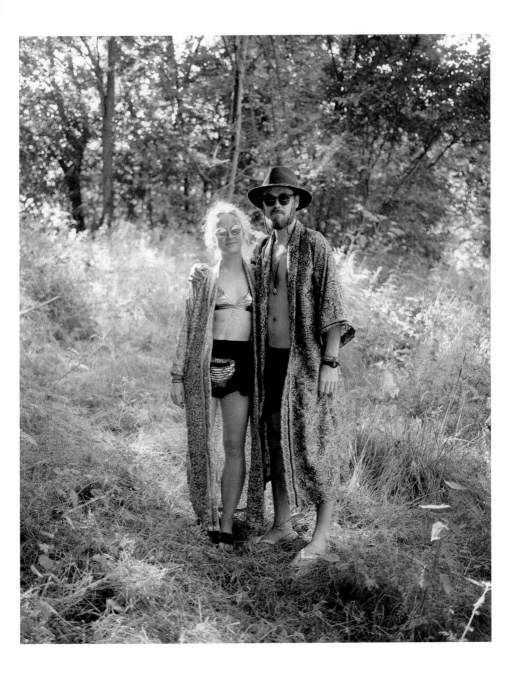

Noisily Festival, Leicestershire

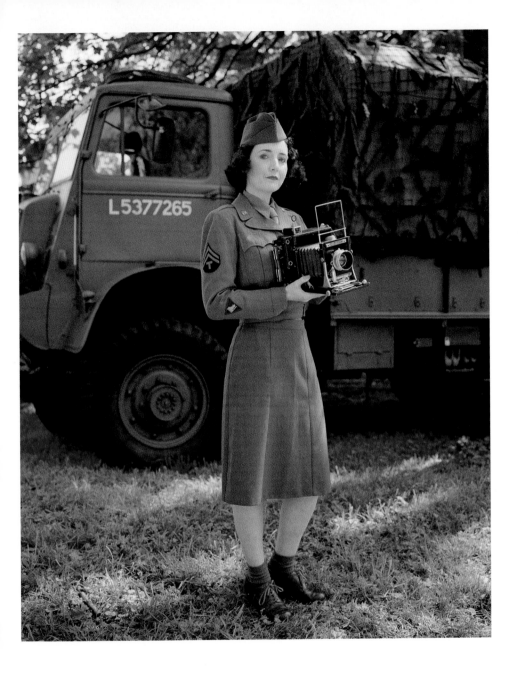

Royal Gunpowder Mills VE Weekend, Essex

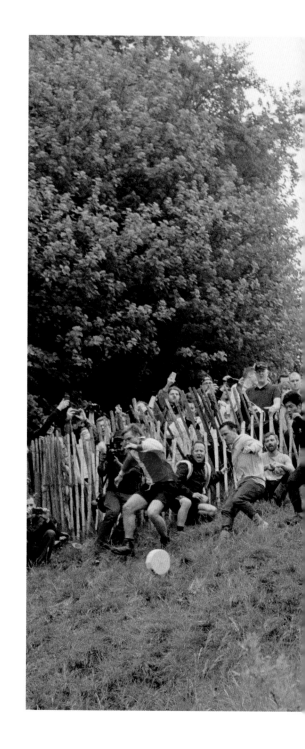

Cooper's Hill Cheese Rolling,
Gloucestershire

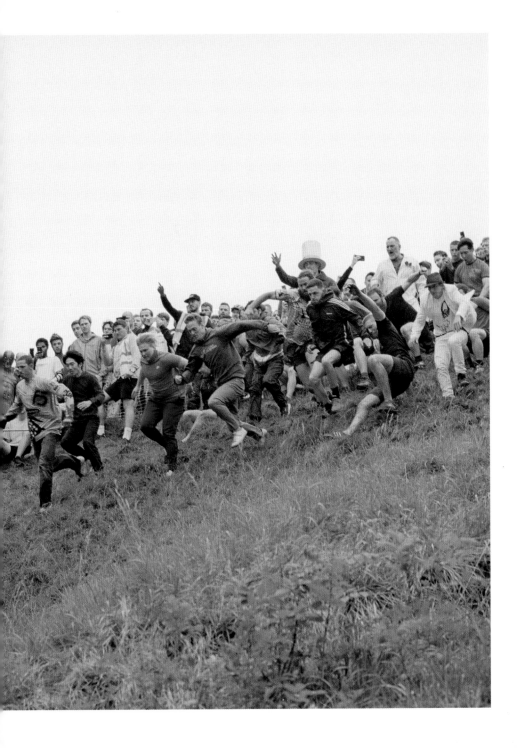

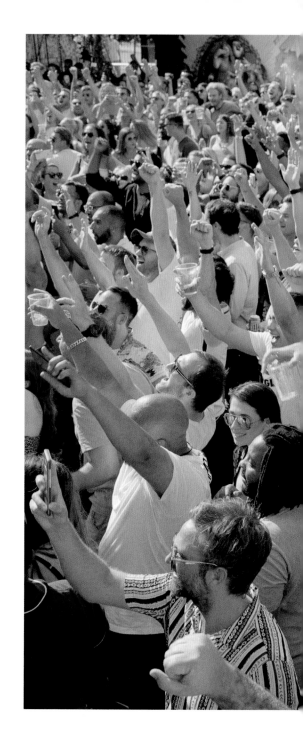

World Cup 2018 England vs Sweden,
Shoreditch, London

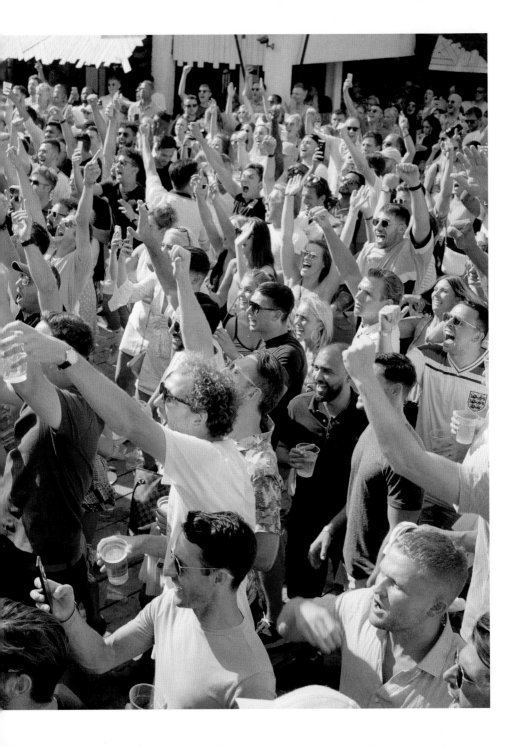

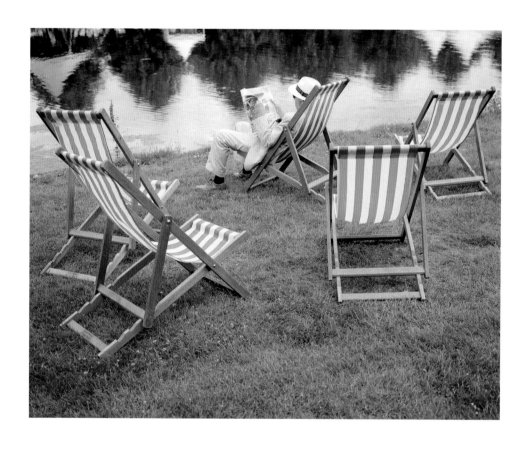

RHS Hampton Court Palace Garden Flower Show, London

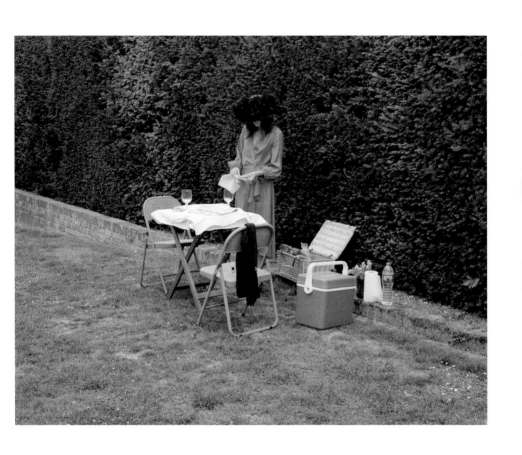

Glyndebourne Festival Opera, Sussex

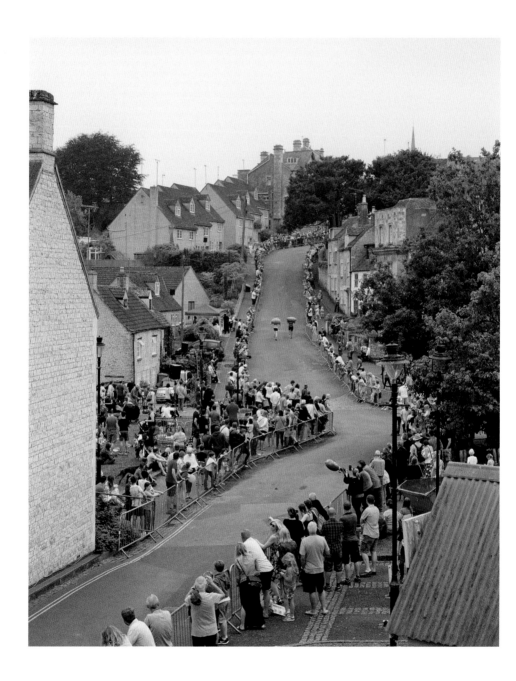

Tetbury Woolsack Races, Gloucestershire

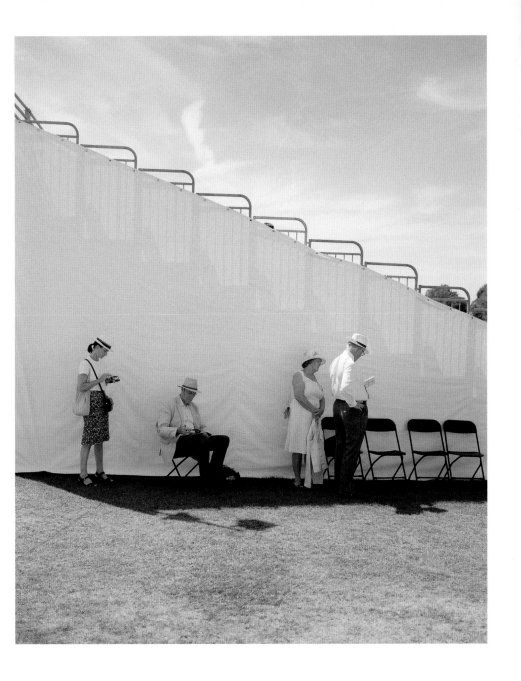

Henley Royal Regatta, Oxfordshire

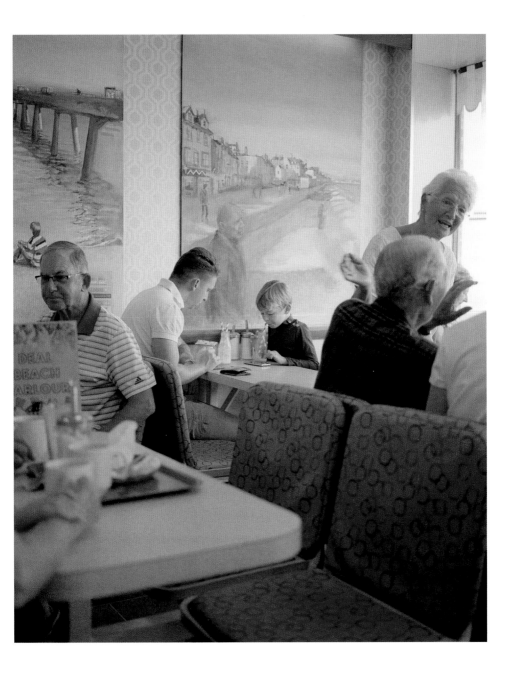

Deal Beach Parlour, Kent

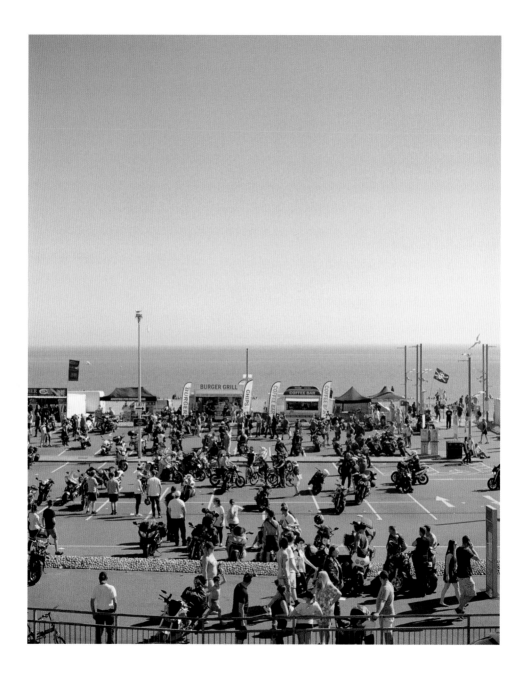

Mayday Run, Hastings

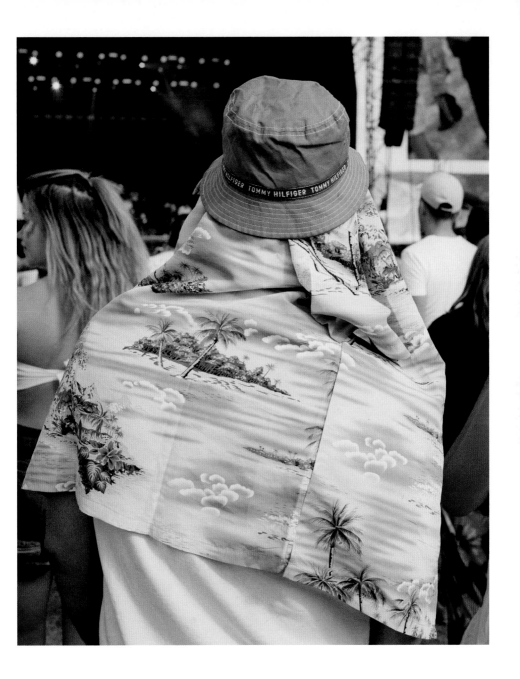

Bestival, Dorset

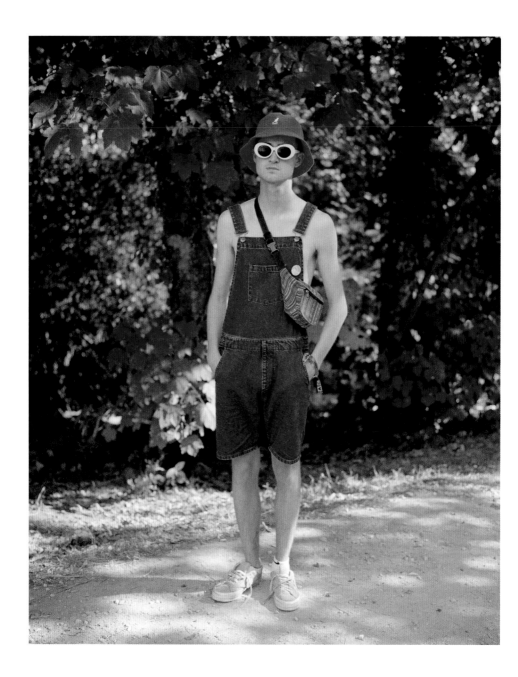

Bestival, Dorset

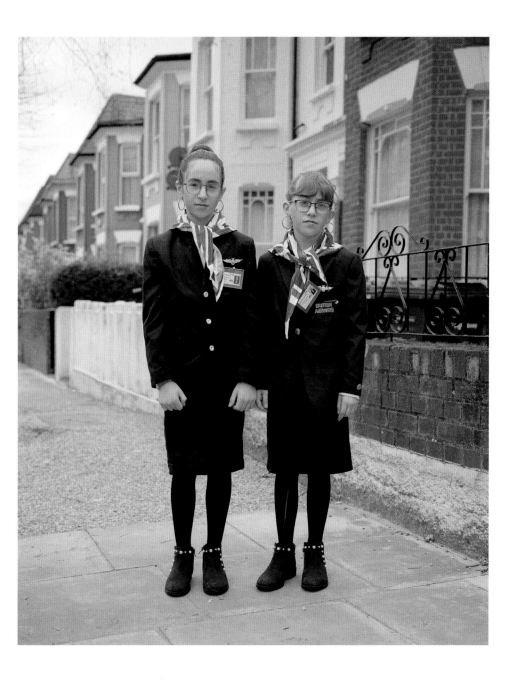

Purim, Stamford Hill, London

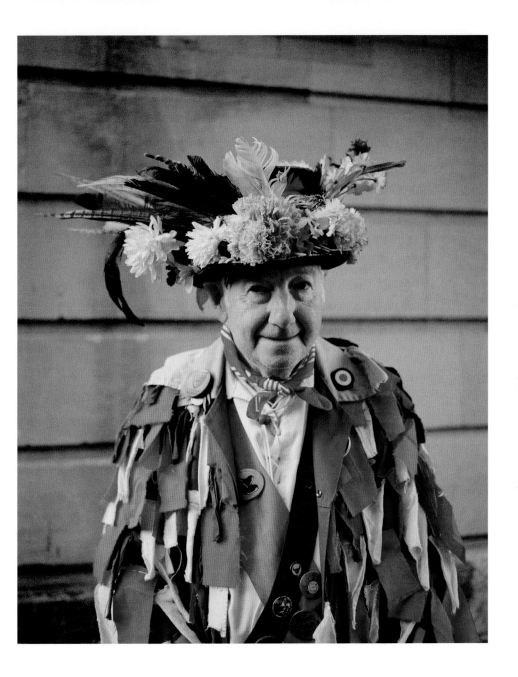

May Morning, Oxford

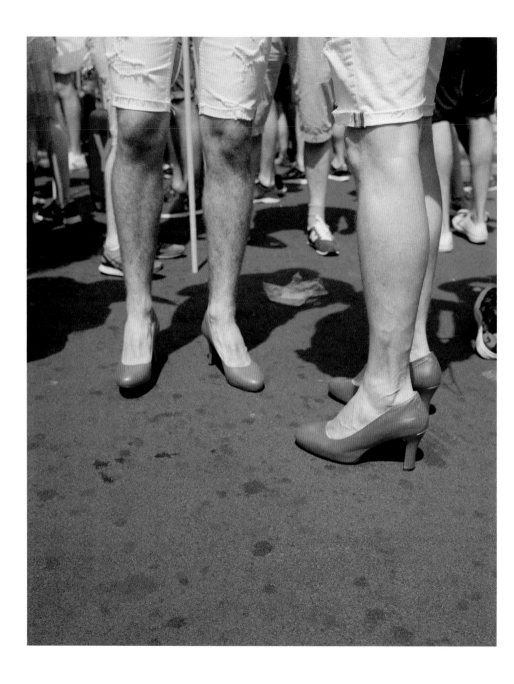

Pride, Oxford Circus, London

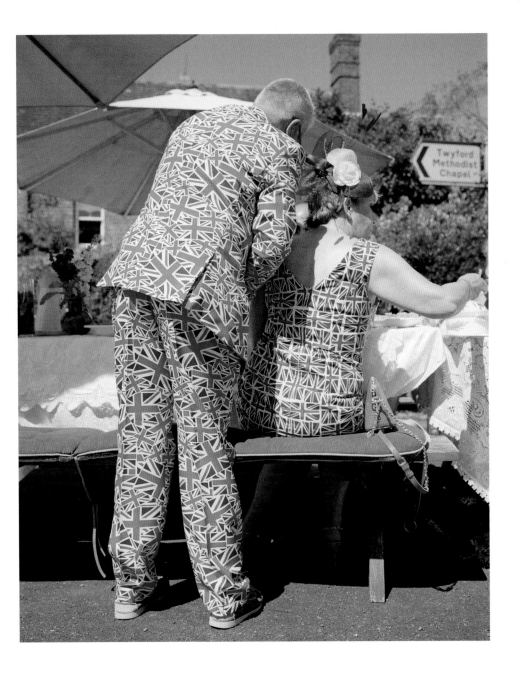

Royal Wedding Day street party, Hampshire

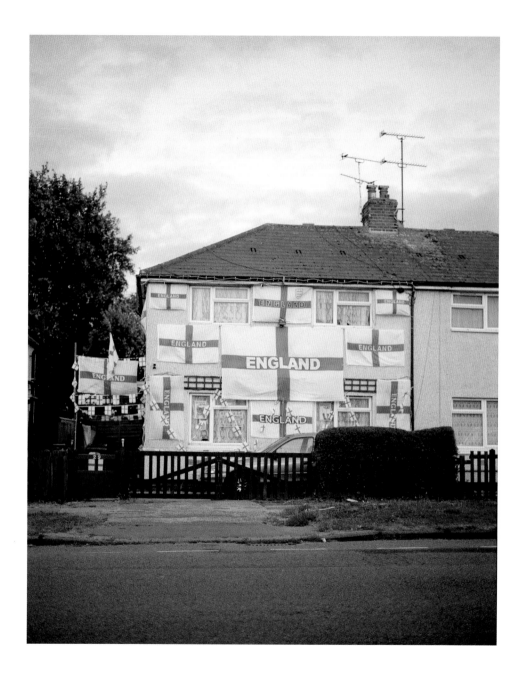

World Cup 2018 England vs Tunisia, Essex

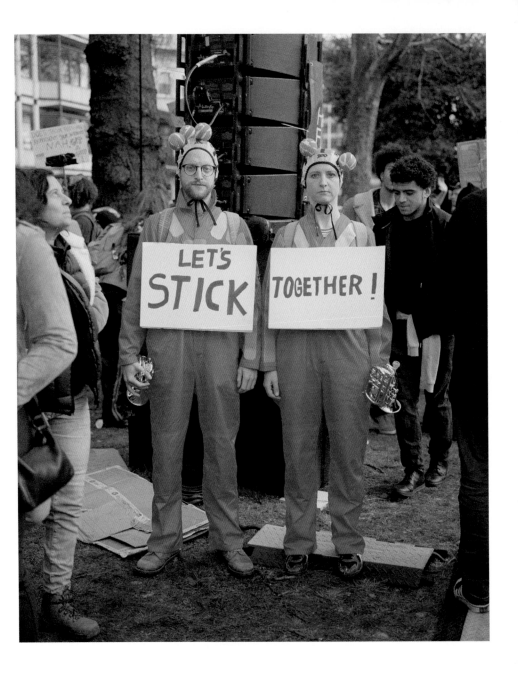

People's Vote march, Park Lane, London

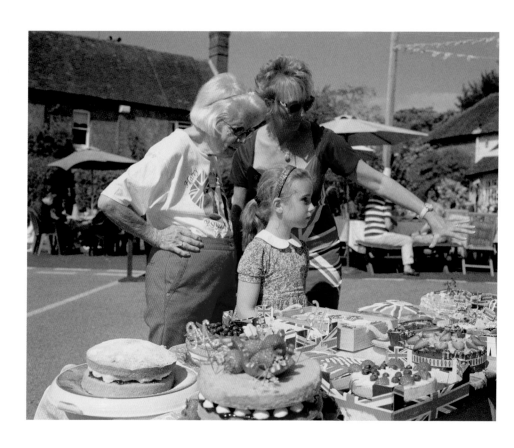

Royal Wedding Day street party, Hampshire

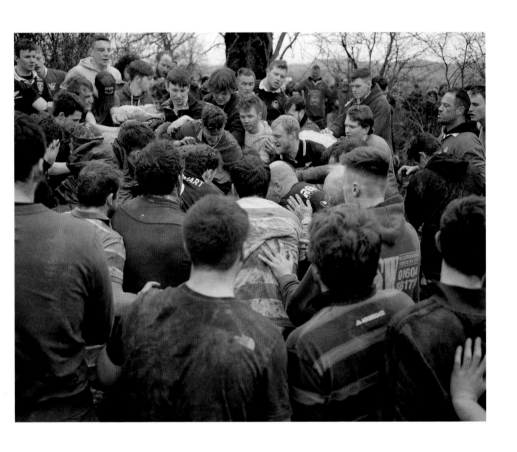

Hallaton Bottle Kicking, Leicestershire

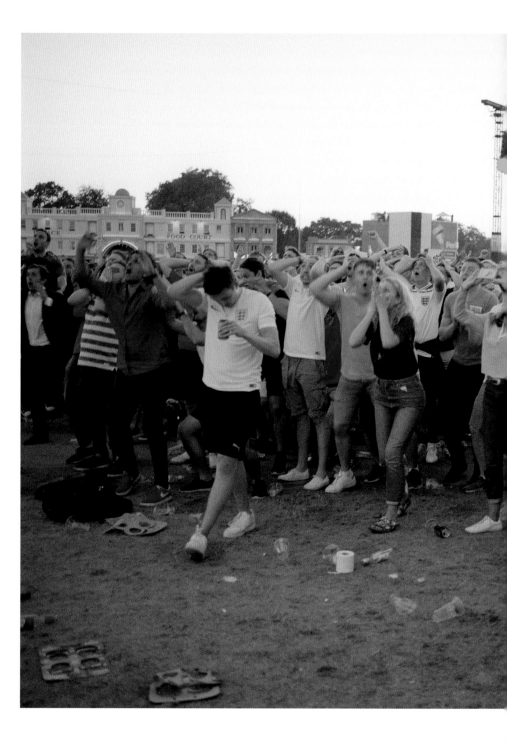

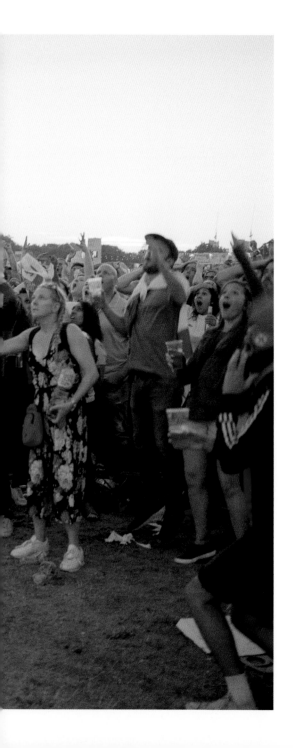

World Cup 2018 England vs Belgium,
Hyde Park, London

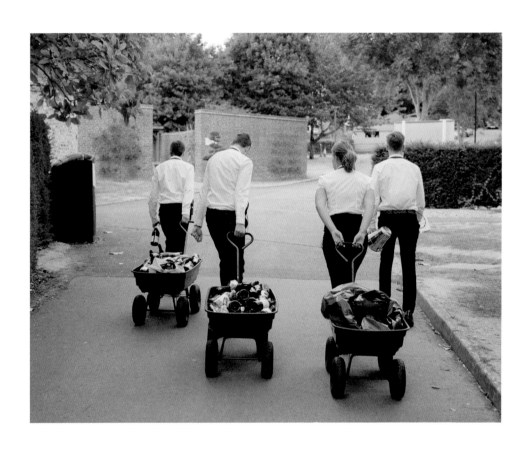

Glyndebourne Festival Opera, Sussex

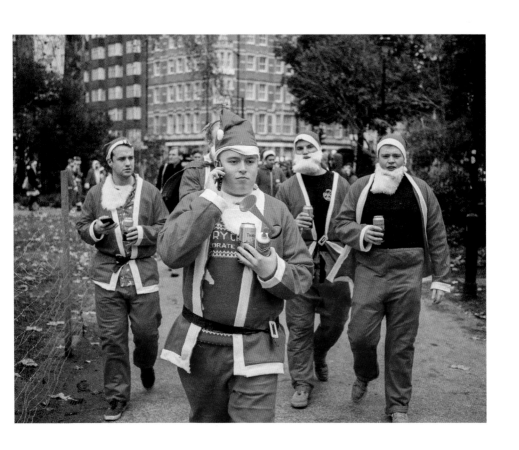

Santacon pub crawl, Russell Square, London

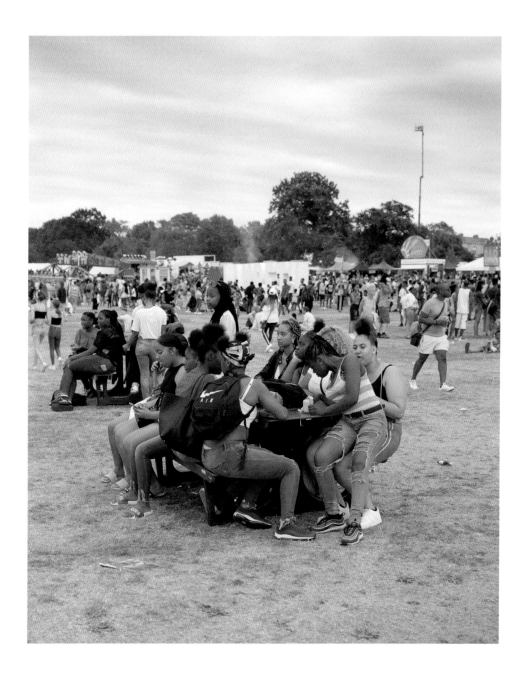

Lambeth Country Show, Brockwell Park, London

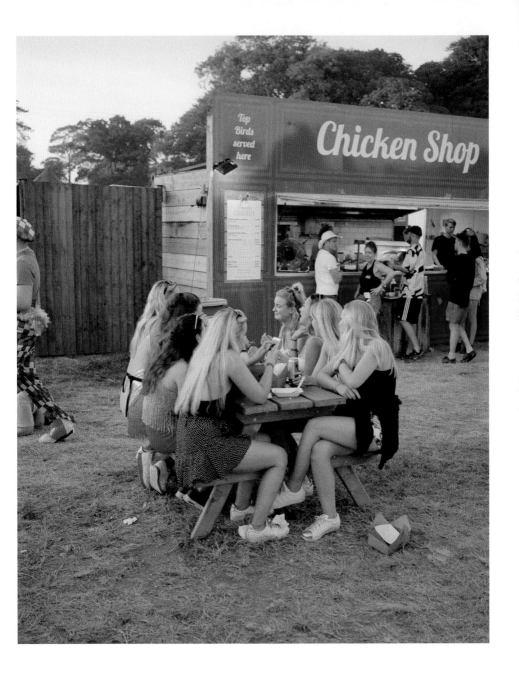

Bestival, Dorset

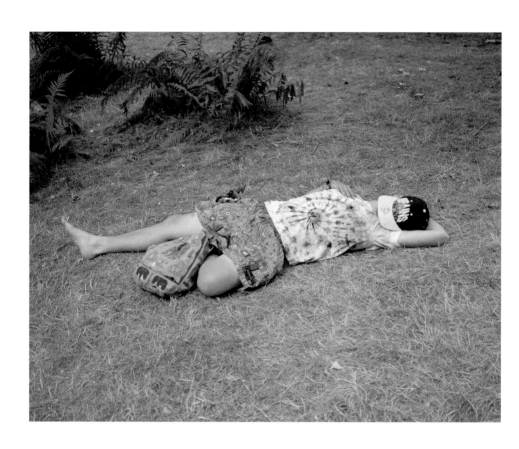

Noisily Festival, Leicestershire

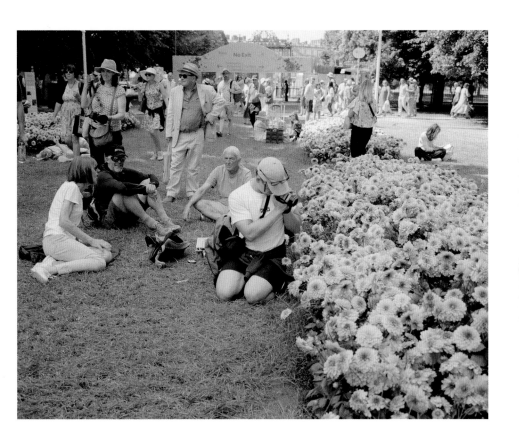

RHS Hampton Court Palace Garden Flower Show, London

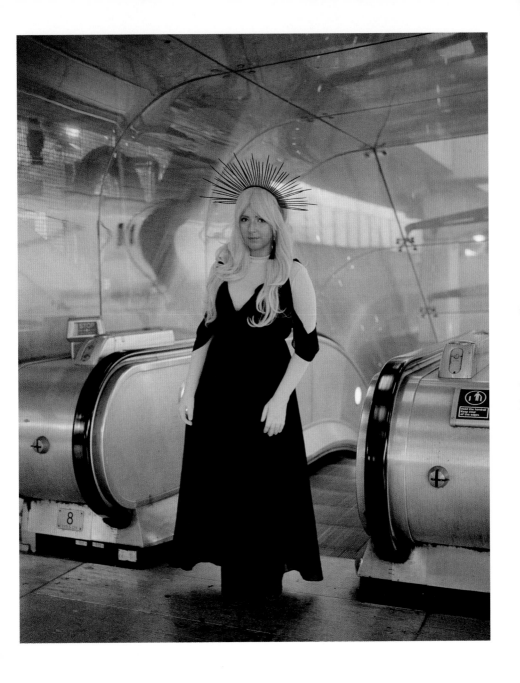

MCM Comic Con, Canning Town, London

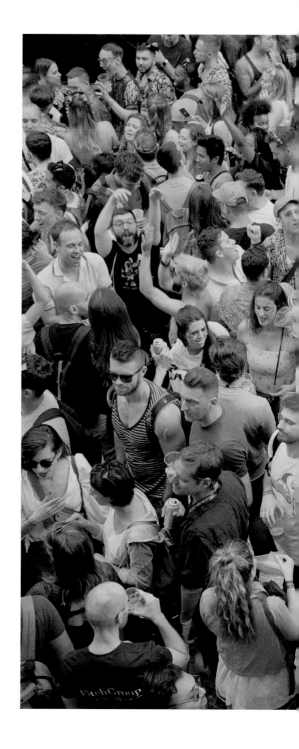

Pride, Soho, London

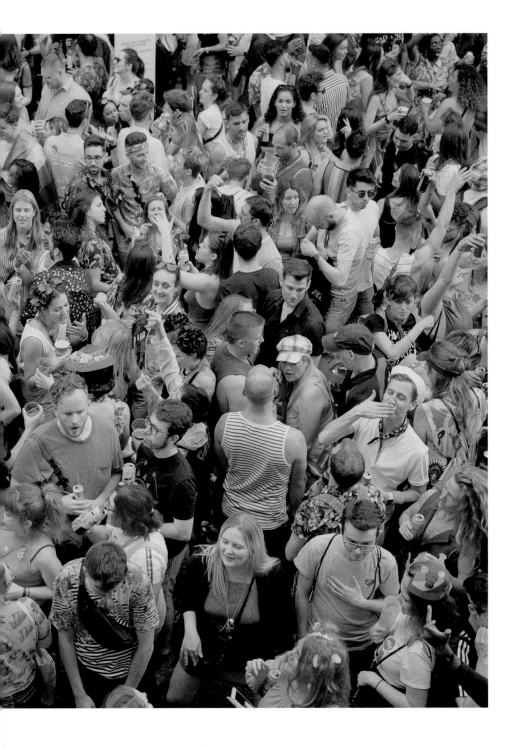

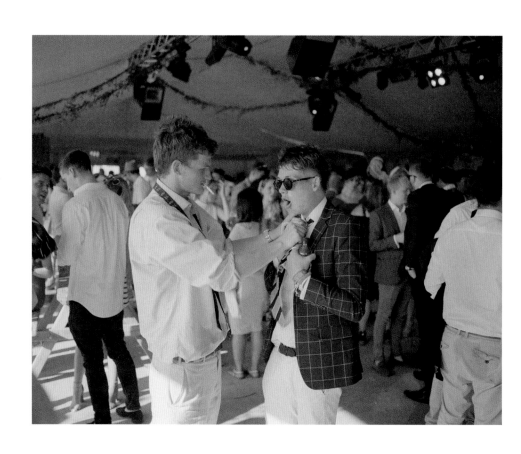

Henley Royal Regatta, Oxfordshire

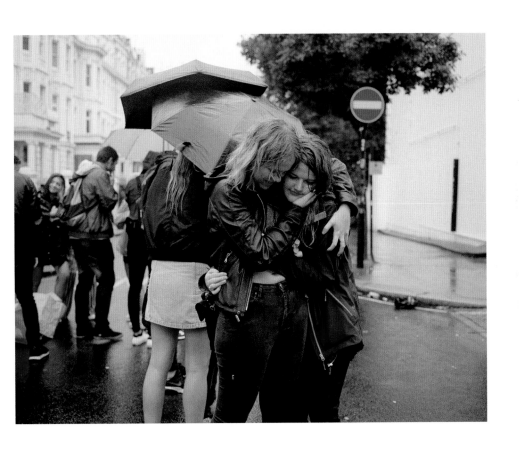

Notting Hill Carnival, London

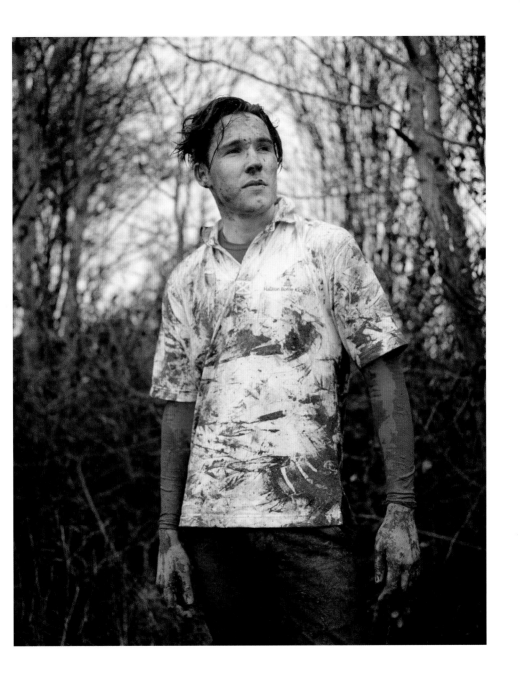

Hallaton Bottle Kicking, Leicestershire

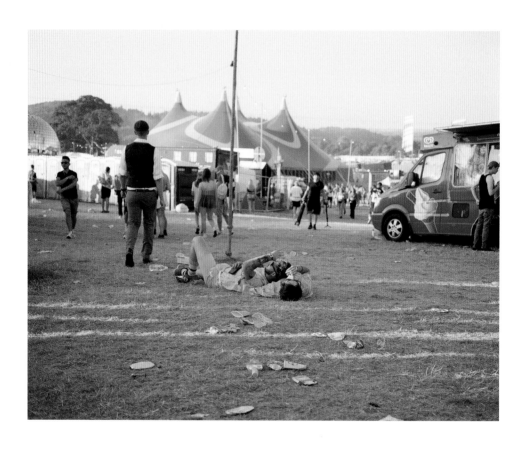

Bestival, Dorset

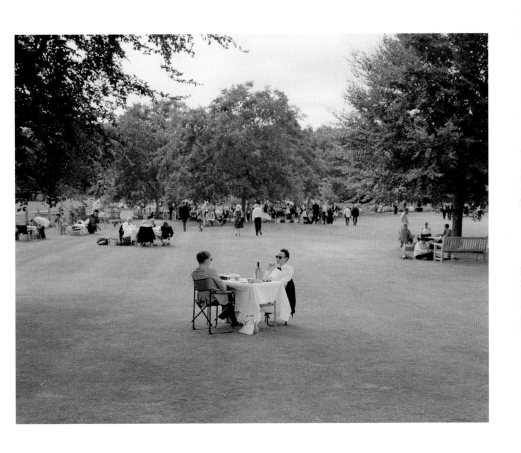

Glyndebourne Festival Opera, Sussex

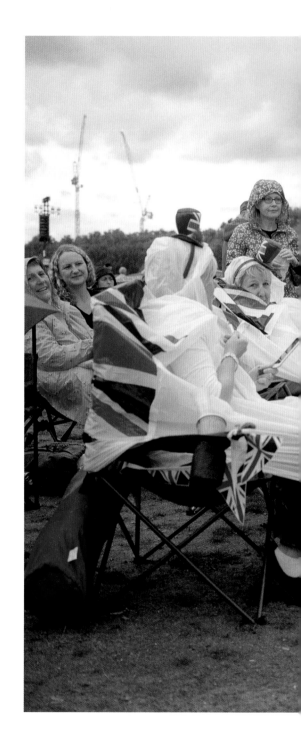

Last Night of the Proms,
Hyde Park, London

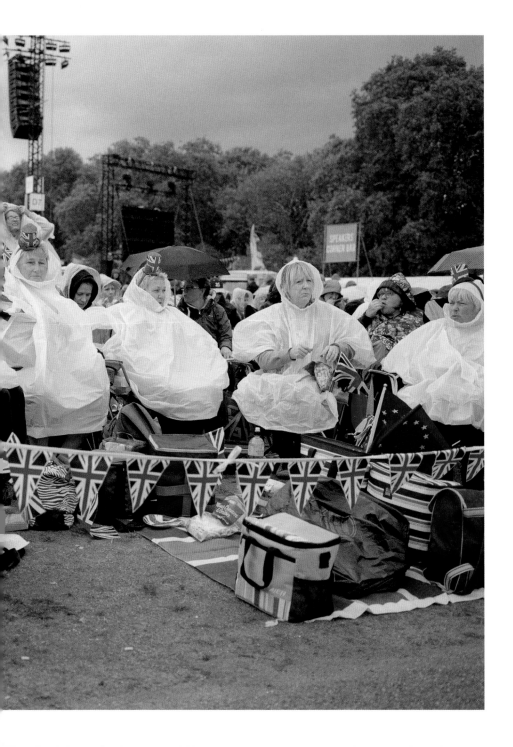

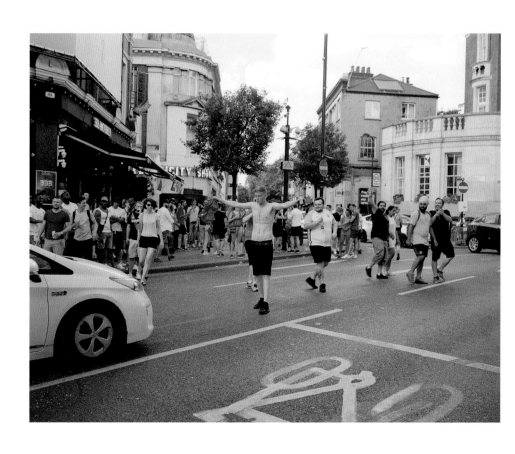

World Cup 2018 England vs Sweden, Shoreditch, London

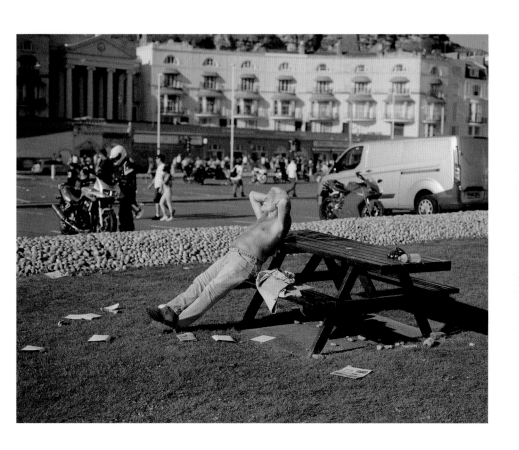

Mayday Run, Hastings

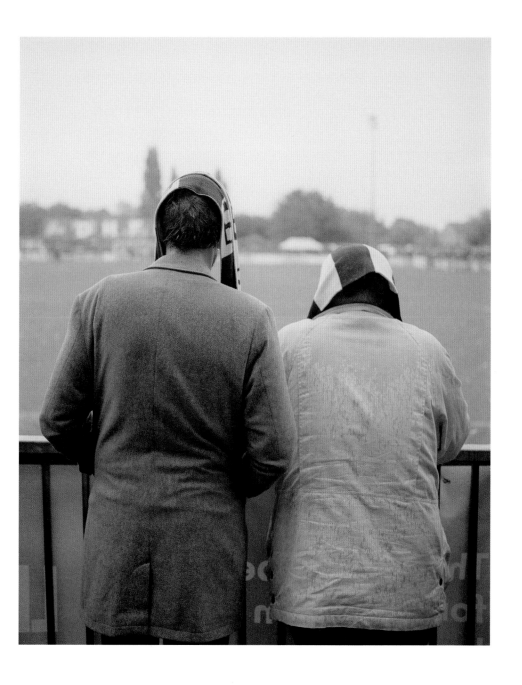

Non League day (Dulwich Hamlet FC vs Weymouth FC), London

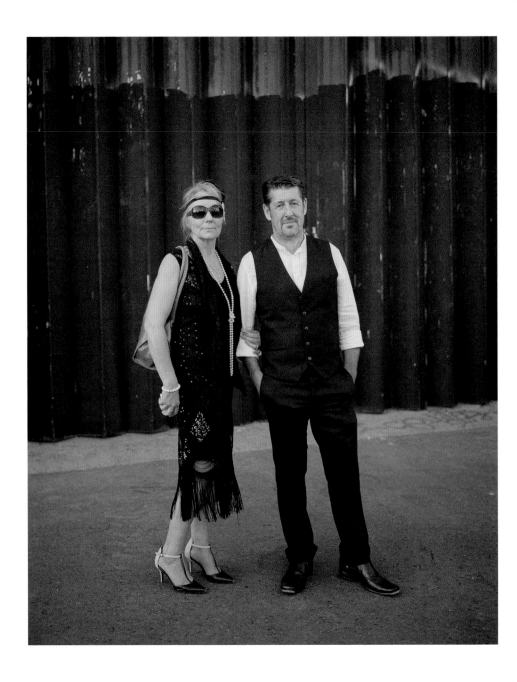

Peaky Blinders Festival, Birmingham

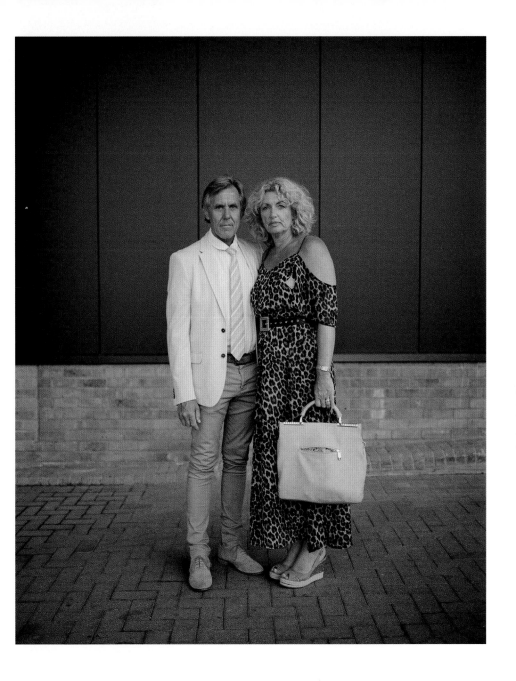

The Championships, Wimbledon, London

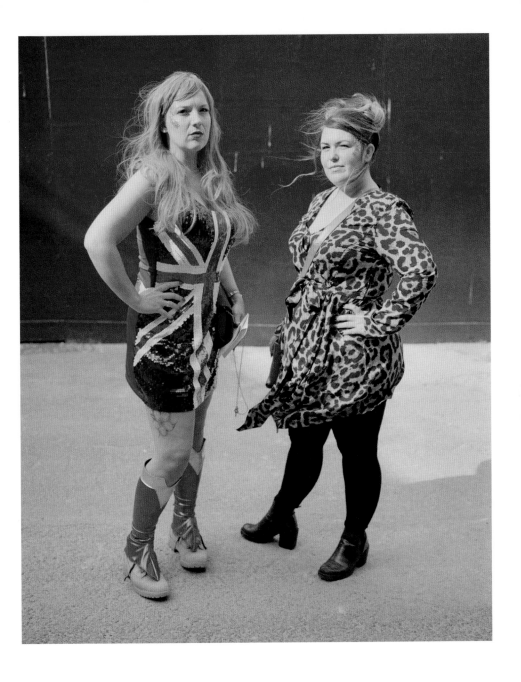

Spice World – 2019 Tour, Wembley Stadium, London

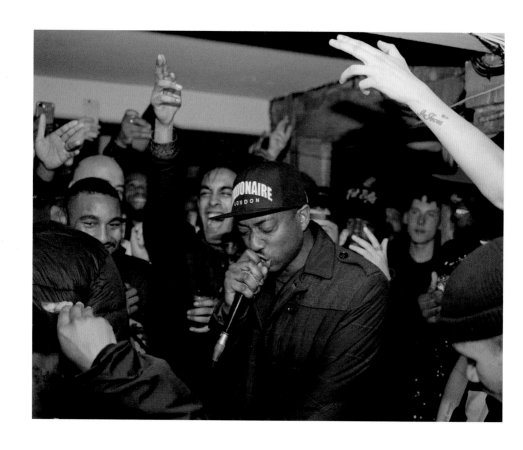

DJ Argue presents Hell in a Cell 2, Shoreditch, London

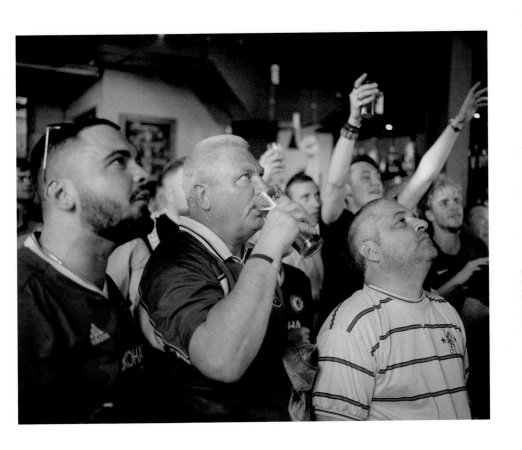

FA Cup Final, Chelsea, London

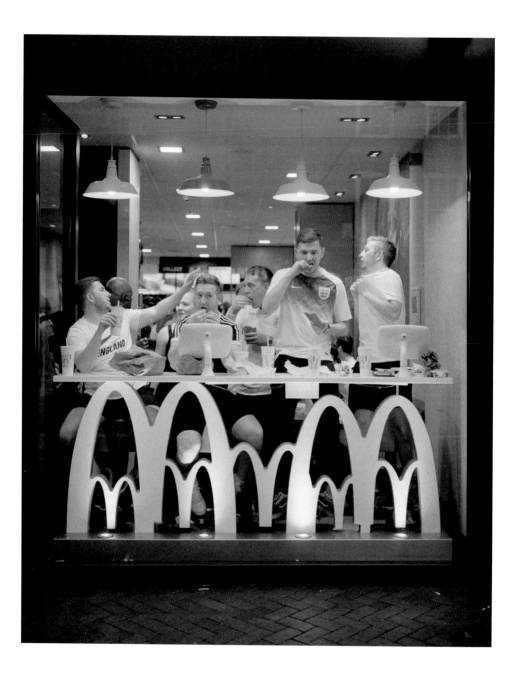

World Cup 2018 England vs Belgium, Reading

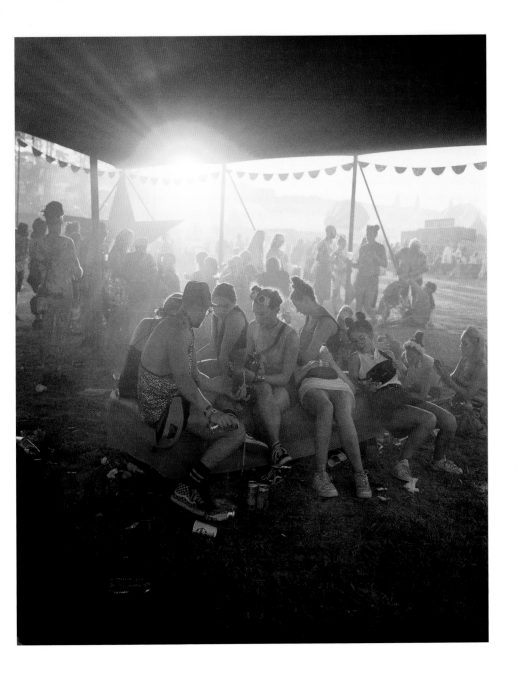

Bestival, Dorset

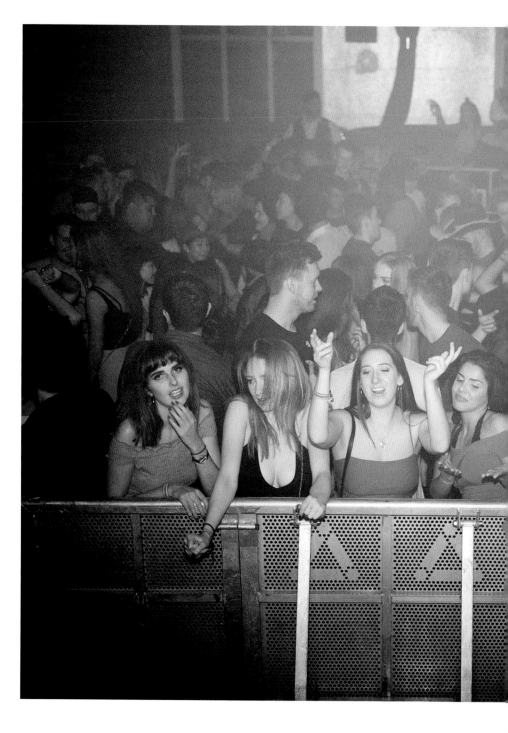

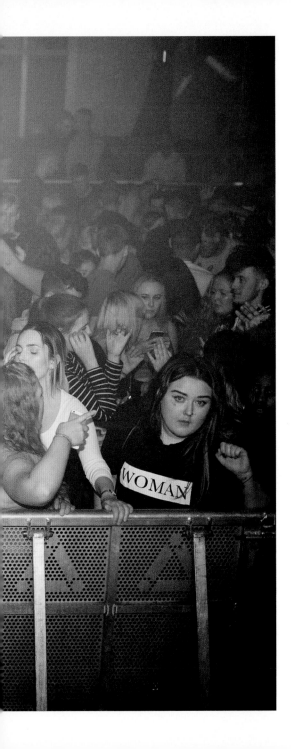

Superbull Freshers' Friday, Leeds

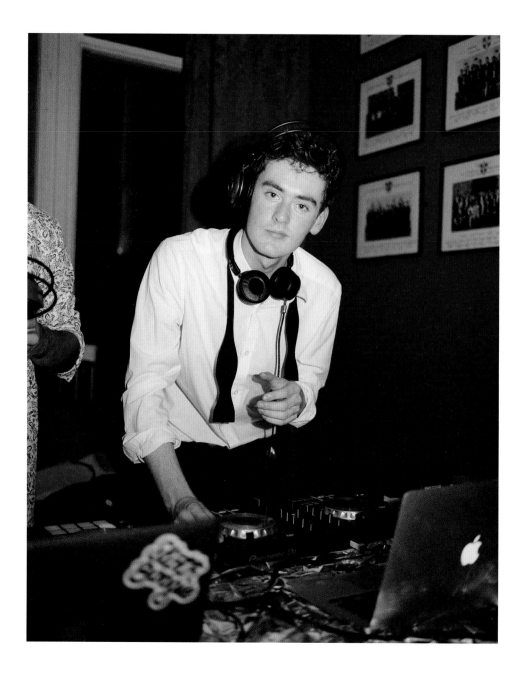

Cambridge Union Masquerade Freshers' Ball, Cambridge

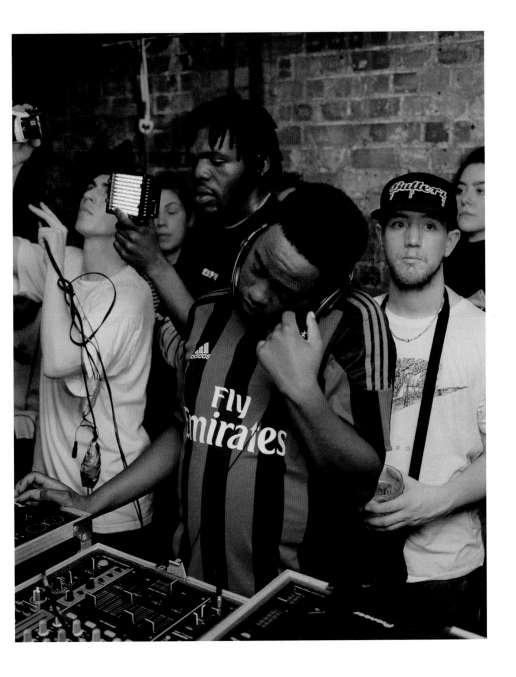

DJ Argue presents Hell in a Cell 2, Shoreditch, London

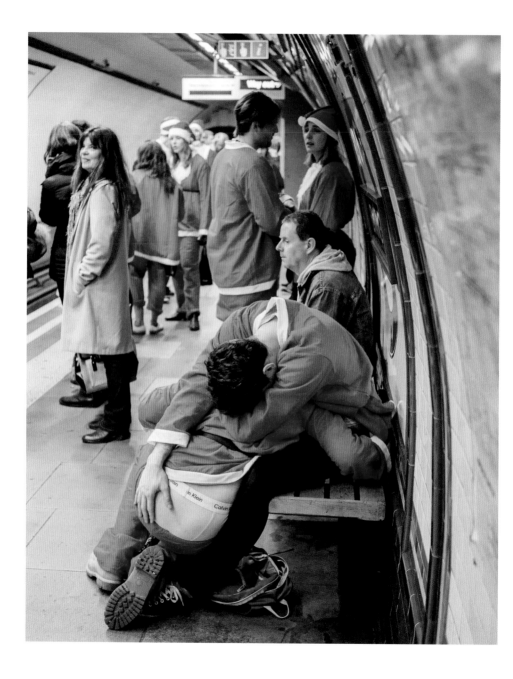

Santacon pub crawl, Tottenham Court Road, London

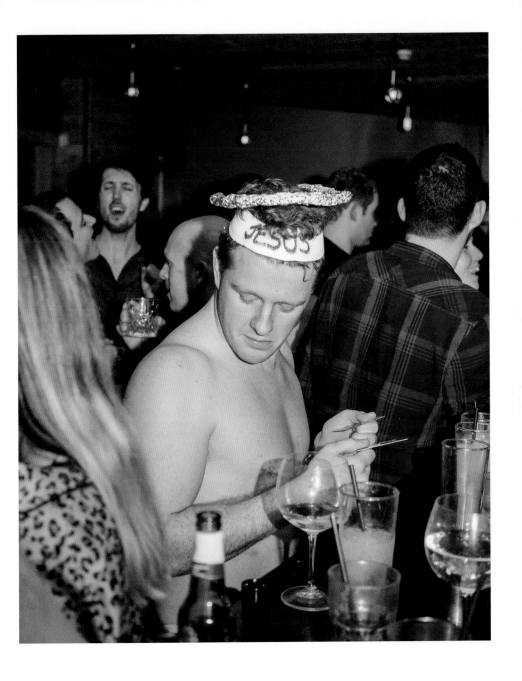

Sinsations Christmas PJ Party, Chelsea, London

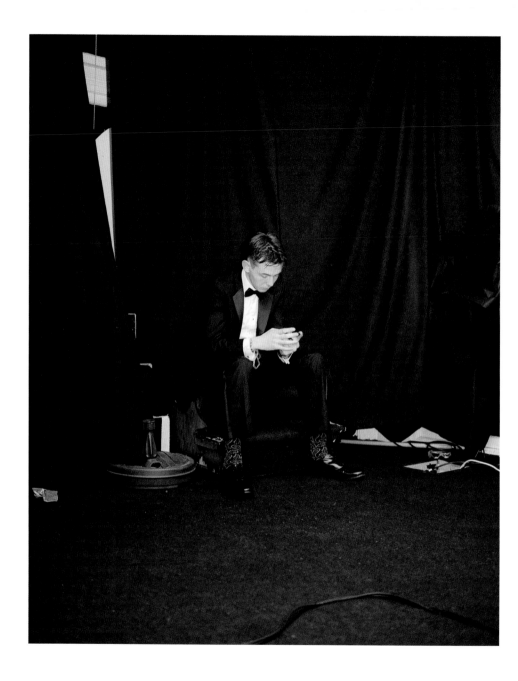

Cambridge Union Masquerade Freshers' Ball, Cambridge

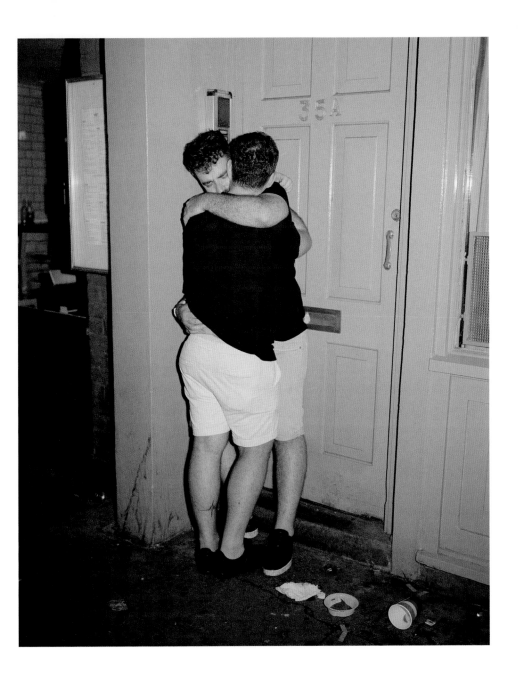

Pride, Soho, London

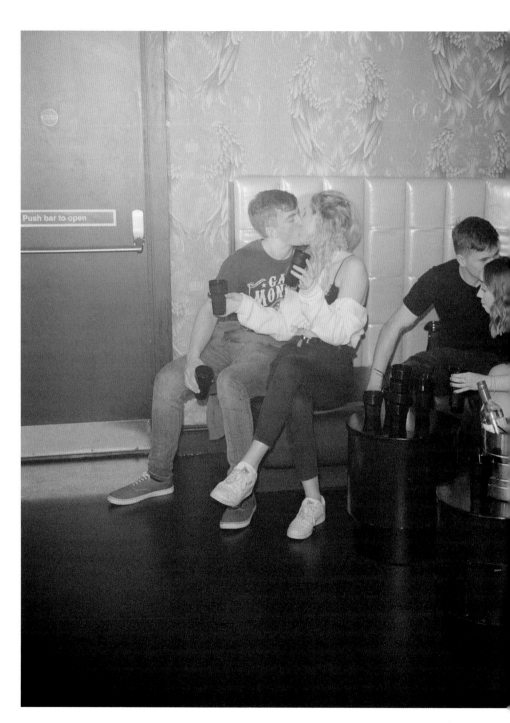

Superbull Freshers' Friday, Leeds

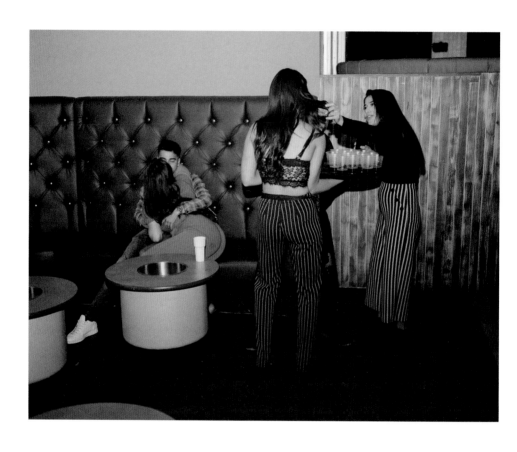

Superbull Freshers' Friday, Leeds

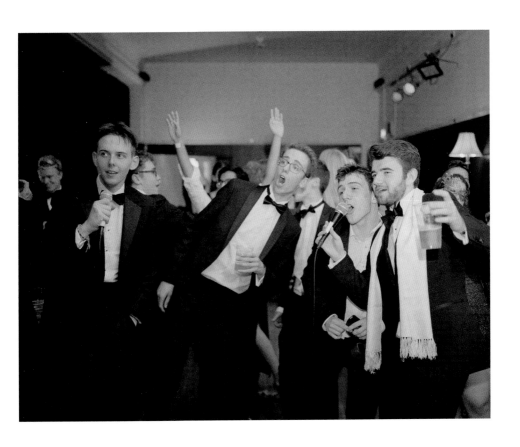

Cambridge Union Masquerade Freshers' Ball, Cambridge

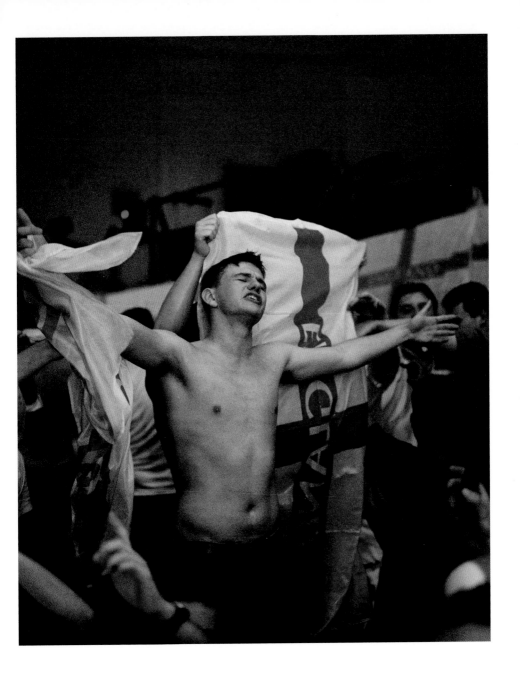

World Cup 2018 England vs Tunisia, Essex

Glossary

BESTIVAL
A four-day music festival set up by DJ and record producer Rob da Bank. The festival ran between 2004 and 2018, and was well known for its themed fancy dress days. In 2010, 55,000 festival goers set a Guinness World Record for the most people in fancy dress at any one event.

BROADSTAIRS DICKENS FESTIVAL
Held in honour of the novelist Charles Dickens, this annual festival includes a production of one of Dickens' novels. The fete first began in 1937, when the owner of Dickens House conceived the idea of commemorating the centenary of the author's first visit by putting on a production of *David Copperfield*, a novel written in the town.

BUCKS COUNTRY SHOW
The agricultural show began in 1859 and takes place at the end of summer in Weedon Park, Buckinghamshire.

CAMBRIDGE MASQUERADE FRESHERS' BALL
A black tie event with live bands, DJs and a casino to welcome new Cambridge under-graduates to the Cambridge Union Society. The organisation began in 1815 and is the oldest continuously running debating and free speech society in the world.

COOPER'S HILL CHEESE ROLLING
Gloucestershire's Cooper Hill has been host to the annual spring bank holiday cheese rolling event since the 1800s. From the top of the hill, a 3-4kg round of Double Gloucester cheese is sent rolling down, with competitors racing down the hill after it. The first person over the finish line at the bottom of the hill wins the cheese. Cheese rolling is thought to have pagan origins as bundles of burning brushwood were rolled down the hill to represent the birth of the New Year after winter.

FA CUP FINAL
The Football Association Challenge Cup is the oldest existing football competition in the world, beginning in the 1871-72 season. Traditionally, the FA Cup Final takes place at Wembley Stadium, London.

GLYNDEBOURNE FESTIVAL OPERA
Five or six operas run annually from May until August, including at least one by Mozart, and all are performed in their original languages by international casts. Glyndebourne takes place in the grounds of English aristocratic Christie family, who started the festival in 1934. Performances start in the afternoon, with a long interval enabling opera-goers to picnic on the lawns.

HALLATON BOTTLE KICKING
On Easter Monday, two neighbouring Leicestershire villages try to move a wooden cask across two streams one mile apart, by any means possible. The competition originates from the eighteenth century, when two Hallaton village ladies were saved from a

raging bull by a hare. They showed gratitude by donating to the church, on the basis each Easter Monday the vicar would provide a hare pie, twelve penny loaves and two barrels for the poor. One year, residents from the neighbouring village of Medbourne stole the beer, thus beginning the village rivalry.

HELL IN A CELL

A grime clash hosted by DJ Argue in Shoreditch, London. Originating in 1960s Jamaican dancehall culture, the sound-clash has been a central tenet of a number of UK sounds, including jungle, UK garage and grime.

HENLEY ROYAL REGATTA

Held annually by the town of Henley-on-Thames, Surrey, the regatta pre-dates any national or international rowing organisation. It is a fixture of the English summer season, with a strict dress code – The Stewards' Enclosure permits lounge suits for men, women are to wear dresses or skirts with hemlines below the knee, and hats are encouraged.

JACK IN THE GREEN

The tradition most likely originates from the creation of intricate garlands of flowers during the seventeenth century, which were carried by milkmaids during May Day celebrations. The Jack covered in foliage and flowers, parades or dances, often accompanied by attendants, as well as Morris dancers, musicians and assorted unusual characters.

LAMBETH COUNTRY SHOW

The free community gathering funded by Lambeth Council brings a traditional country fair to inner-city south London. About 180,000 people attend the Brockwell Park show for sheep-shearing, jousting shows, wood-whittling, local cider and live music.

LAST NIGHT OF THE PROMS

The concert takes place at Royal Albert Hall in London, with an outdoor screening and performances in Hyde Park. It traditionally combines popular classics with patriotic numbers, such as 'Rule Britannia', and culminates with 'Auld Lang Syne'. The concert marks the end of the BBC Proms – a summer season of daily orchestral classical music concerts that can be traced back to 1895.

SUPERBULL FRESHERS' FRIDAY

Superbull Freshers' Friday is a student night coinciding with Leeds University freshers' week at super-club PRYZM.

MAY MORNING

Magdalen College Choir sing 'Hymnus Eucharisticus', a seventeeth-century hymn, from the top of Magdalen Tower in Oxford, at 6am, on the 1st of May each year. The 500-year-old Oxford tradition unites the university city to celebrate spring. Residents mix with students, who have stayed up the night before, taking advantage of temporary relaxed licensing laws in pubs.

MAYDAY RUN

Britain's biggest free-to-attend bike festival. Hastings has been a destination for bikers since the mods and rockers influx of 1964.

MCM COMIC CON, LONDON

A speculative fan fiction convention, held twice yearly at the Excel Centre, London. Comic Con focuses on video games, sci-fi and cosplay, and has expanded to run across three days.

NOISILY FESTIVAL
The four-day Leicestershire countryside festival is a celebration of psychedelic art and culture, and the music programme covers the whole spectrum of electronic music.

NON-LEAGUE DAY
A day set aside in English football where supporters are encouraged to attend local non-league matches. The non-profit, volunteer-run initiative began in 2010, and coincides with a break in fixtures from the top two divisions, the Premier League and Champions League.

NOTTING HILL CARNIVAL
The annual August bank holiday is led by members of the British West Indian community, attracting two and a half million people. The carnival began in 1966, created by human rights activist Claudia Jones, to provide a catalyst for change after an Antiguan carpenter was murdered in a racially motivated attack in 1959.

PEAKY BLINDERS FESTIVAL
The *Peaky Blinders* festival began in 2019, based on the eponymous cult crime drama television series. It takes place at the Digbeth quarter of Birmingham, a prominent location in the fictional programme.

PEOPLE'S VOTE MARCH
In one of the largest demonstrations in British history, an estimated one million marched in central London to demand another EU referendum, as MPs searched for a way out of the Brexit impasse.

PRIDE, LONDON
The annual LGBT+ festival and parade is held each summer in central London. It is one of the longest running in UK, attracting an estimated one million visitors.

PURIM
Orthodox Jewish children in fancy dress and adults take to the streets in London to celebrate the annual feast of Purim, celebrated by Jewish communities around the world with parades and costume parties. Purim commemorates the defeat of Haman, the adviser to the Persian king, and his plot to massacre the Jewish people, 2,500 years ago, as recorded in the biblical book of Esther. Stamford Hill in north London has the largest concentration of Charedi Hasidic Jews in Europe.

RHS HAMPTON COURT PALACE GARDEN FLOWER SHOW
One of the largest flower shows in the world is run by the Royal Horticultural Society, and takes place each July at Hampton Court Palace.

ROYAL GUNPOWDER MILLS VE WEEKEND
The weekend brings to life the last months of World War Two. Over 300 re-enactors from all over the world assemble in a show area of tents, jeeps, barracks and field kitchens.

ROYAL WEDDING DAY WINDSOR
Tens of thousands of well-wishers gathered to catch a glimpse of Prince Harry and Meghan Markle, following the ceremony at St George's Chapel in Windsor Castle. It was not until Prince Albert, Duke of York's marriage to Lady Elizabeth Bowes-Lyon in 1923 that royal weddings became public affairs. They were married to great fanfare in order to lift the spirits of the nation after World War One.

ROYAL WEDDING STREET PARTIES
Street parties celebrating the wedding took

place up and down the country. The BBC waived the TV licence fee for communities wanting to screen the wedding live, and many councils waived charges for road closures. Street parties in the UK started in 1919 as 'Peace Teas' after World War One.

SANTACON
An annual charity pub crawl traditionally taking place in London one Saturday every December. Revellers dress as Santa, reindeer, elves and other Christmas icons. It originates from Danish activist group Solvognen. In 1974 they satirised the rampant consumerism associated with Christmas, by dressing up as Santas, and handing out items from the shelves of department stores as presents.

SHAMBALA FESTIVAL
A family-run festival with an anti-corporate, independent, sustainability and community focus that takes places over the August bank holiday weekend in the Northamptonshire countryside. Traditionally, thousands cross-dress for 'Fruity Fridays' and on Saturday for the 'Fancy Dress Carnival'.

SINSATIONS CHRISTMAS PJ PARTY
A one-off, Christmas-themed night at Chelsea Lodge, a west London nightclub.

SPICE WORLD – 2019 TOUR
The iconic 1990s girl-group Spice Girls played to 80,0000 fans at Wembley Stadium for three nights, as part of their reunion tour.

TETBURY WOOLSACK RACES
In 1972, two pub landlords created a sack race at the Tetbury Festival in Gloucestershire. The races are between The Royal Oak (the bottom of the hill) and The Crown (at the top).

THE CHAMPIONSHIPS
The oldest tennis tournament in the world held at the All England Club in Wimbledon, London. The Championships began in 1877 and is one of the four Grand Slam tennis tournaments. Wimbledon traditions include a strict all-white dress code for competitors and royal patronage.

WHITSTABLE OYSTER FESTIVAL
The festival can be traced back to Norman times when fishermen held a service of thanksgiving around the feast day of St James of Compostella, considered the patron saint of oystermen. The oyster festival was developed to promote the recently revived local fishing industry, which had been virtually wiped out in the 1920s by a combination of disease and overfishing.

WINDLESHAM PRAM RACE
The annual Windlesham Boxing Day Pram Race is a charity event that sees runners complete a 3.5 mile course through Windlesham village in fancy dress, stopping at local pubs along the way. Prizes include: The Best Dressed Pram, The Best Engineered Pram and The Fastest Pram.

WORLD CUP SEMI-FINAL
Thirty thousand free tickets were made available by the Mayor of London for a public screening of the 2018 England's semi-final match with Croatia in Hyde Park, London. The biggest public screening of a football match in the country for 22 years, and the first time since 1990 England have played in a World Cup semi-final.

Trivial Pursuits: The English at Play

First edition

Copyright © Hoxton Mini Press 2020. All rights reserved.

All photographs © Orlando Gili
Introduction text © Lucy Davies
Design and sequence by Friederike Huber and Orlando Gili
Production by Anna De Pascale
Copy editing by Faith McAllister
Design support by Daniele Roa

Image on p.4: Whitstable Oyster Festival, Kent

A CIP catalogue record for this book is available from the British Library

ISBN 978-1-910566-75-6

First published in the United Kingdom in 2020 by Hoxton Mini Press

Printed and bound by Livonia, Latvia

To order books, collector's editions and signed prints please go to:
www.hoxtonminipress.com